# DIRTY BASTARD WRAPPED IN BLUE

ADAM KUNDE

Copyright © 2025 Adam Kunde.

All rights reserved. No part of this book may be used or reproduced by any means, graphic, electronic, or mechanical, including photocopying, recording, taping or by any information storage retrieval system without the written permission of the author except in the case of brief quotations embodied in critical articles and reviews.

Balboa Press books may be ordered through booksellers or by contacting:

Balboa Press
A Division of Hay House
1663 Liberty Drive
Bloomington, IN 47403
www.balboapress.com.au
AU TFN: 1 800 844 925 (Toll Free inside Australia)
AU Local: 0283 107 086 (+61 2 8310 7086 from outside Australia)

Because of the dynamic nature of the Internet, any web addresses or links contained in this book may have changed since publication and may no longer be valid. The views expressed in this work are solely those of the author and do not necessarily reflect the views of the publisher, and the publisher hereby disclaims any responsibility for them.

Interior Image Credit: Adam Kunde

ISBN: 979-8-7652-0106-0 (sc)
ISBN: 979-8-7652-0105-3 (e)

Library of Congress Control Number: 2024923107

Print information available on the last page.

Balboa Press rev. date: 01/17/2025

**BALBOA.PRESS**
A DIVISION OF HAY HOUSE

# DIRTY BASTARD WRAPPED IN BLUE

Adam Kunde

Time I'd never understand naked on my bedroom floor unexplainable was just around the corner. Head first Twisting through dimensions Bryan's world changed for better changed for worst things he'd least expect closed doors Shone new begins. "Hello young man what's your name", she was fierce eyes of fire fell upon me breathing through her nostrils leaving Bryan feeling lost. "Bryan…"

"Are you normally this shy Bryan." "never usually I'm the loudest person in the room". "We need to move jump on", thick tarnished scales shielded blitzing night sky's finding some way home the only thing on my mind. "So why were you all alone in Pittsworth not many live to tell the tail."

"I wasn't there by choice excuse me miss you never mentioned your name ", it was almost as if she read my mind scared out my brain already she'd glanced into my soul seeking consideration." "Oh how rude of me you can call me Breanna". Our landing came ridged tinny elf's came running to our aid, "check her wings for pesky hum bugs". Breanna wailed unbearably as they dressed her in volcanic ash dismembering every pest, "water!".

Our eyelids glued to our eye balls Peeling them open was going to take a great deal of effort, "don't be such a baby." "Chester pin him down". "It's been two hundred years since I've seen you last what happened to your wing?" "Seth", expressions of sorrow plus extacy reverently throb. "Seth.... he's men have terrorised our people for generations." "Tell me where I can find him." "along the shore's of shallow caves".

Shale tomahawk's rested spiritual independent reckoning came over us all as brothers in arms revenge they'd seek. "Sleep well my brothers for we rise at dawn", unpleasant regards rung ministering chaos erupt raindrops trickle inflicting dramatic composition conartists Master perfection. That morning we woke to the sound of hungry eagles sights I was far from familiar with, "Bryan have you rode one of these before?." "he rides with me he's not from this place".

Deciphering Elberton's Sacred vowels Praised omens rebirth saint crooks ambitious deception discovering delinquents spiteful seeds rot shivering third world convalescents. "See those Valley's we must visit our allies rest with in", those creatures aggregated aggression encouraging Ryan's troops war was on the horizon leaving Ryan restless with glints of hope scattered around the camp site. "Why should we trust Daintree's dwarfs they've followed Seth to war once before what's stopping them from doing it again?" "Shekhua".

Ryan tepid headed Short his stride had been his biggest down fall to many times before be dammed if he was going to let it happen again. "Catch have you ever struck a blade?" "blade..... I haven't even used a hammer yet", Ryan invested much wisdom tainted armour longing tender love and care crafting suitable armour blades fit for kings. "Bryan I refuse!", Breanna did not like the fact of my presence around malicious endeavours doing the best she could to keep her promise help me home.

"I can't let them fight this war alone look at your wing please how else can I pay you back." "you really don't understand how brutal Seth can be you may never see your home ever again". After hours of debate she finally agreed on one condition that she'd be my escort, "take Victor's necklace it Will keep you safe from harm". It's style Unique making me invisible with out warning powers I'd learn to control. After suffering from a terrible fall I'd lost Breanna and all Ryan's troops constantly telling myself everything's going to ok.

"Get back rat bag", stagnation surrounded the ugliest thing I'd ever seen tried removing Victor's necklace drawing my blade stoping it dead in its tracks. "Arrrrrr what are you waiting for." "If you help me get back to my friends I'll let you out of this sticky situation ", befriending stranger's was something I wasn't to familiar with for all I knew he could of been the enemy, "very well than your wish is command". Dark forests howl chanted winds churned speaking tongs with out understanding lost souls begged for redemption.

"Who is it you seek?" "Ryan and his men" "elf's?" "yes you know him" "of course he's reigned for over two hundred years hiding in the shadow's making his Resistance stronger". Insubordination control vagabonds crawled, Uncertain gullies surely consume Innocence, "master... this way", marks of severance ran down his back almost as if he's previous life was one of a runaway slave. "Put that on." "no it stinks like poo." "Unless you want to be wild coyotes lunch be my guest..... funny I can still see your blade besides its the smell were trying to hide". Passing through mountains of gold and sapphires Skeletons pact weighted Influential evicts.

"Boo! Ha." "bloody hell Mackelly you scared the life out of me what brings you to Julius city?", another troubled mutant hooves as hands life had certainly made sinus plans. "Seth's thirsty cee merchants skinned half Keskins woltens I didn't want to be in there way.", Mackelly's Intellectual intelligence was so much greater than my new found company following him was going to be my best chance. Mackelly allowing me to ride him all the way to shallow caves conversations I'd recalled, "kill them both!".

We'd been spotted Unorganised occupants patrol primeval Pirates with scurvy magnetise leaf less mahogany tied us down, "we're doomed". Fifty strong we'd become captive hog tied as pigs leaving our future uncertain triggering mirthful misadventures. "That's not contagious is it." "shut up!" "dam man when was the last time yo nasty ass had a shower." "one more word and off your head". "Arrrrr more soup arrrrr no! Spare me please I don't want to die." "remove his tongue", wrenchingly over crowded contamination unquestionably taken its toll.

13

"How long have you been slaved on this ship for?" "centuries.... don't get to close every one I get close to they execute I Couldn't tell you why". Making our escape was going to take will power along side exhilarating smarts,"what's your master plain Bryan? you got us into this mess remember". For the first time I'd felt hopeless no freedom no friends Clueless left with out anything to say,"Mackelly get the guards attention." "come on man I aren't playing like that why don't you do it". Time stood still pouring sweat I finally gathered the nerve to take up mackelly on his offer as it seemed to be the only way.

14

"Hey! Over here my shackles coming Loose." "remove him from the others". Diabolical daggers faced sandtarhs removing laced nickers epileptic follicles fell stressed jaws fastened, liquorice whip stitch wild roulette rose seasons crumble romance sin honey erotic restraints cascade. "Arrrr stop please not my arrr", kerosene castration amused myself unsteady losing my man hood just wasn't in the cards. Loud thunderous crashes came from behind beasts beyond any man's imagination our luck had just turned. Mackelly pounced taking out every last Pirate coming to my aid unexpectedly, "yea boy! come on arm up…… god dam".

After Retrieving Victor's necklace It allowed us to Open up a whole new can of whoop ass driving those Pirate's back to the hounds of hell. "What on earth are you doing here?", few of daintree's dwarfs had randomly crashed chasing glory evolved into unwanted associations.

"We've been trying to tame these beasts for months as you can see Mackelly weapons of mass destruction we'll conquer Pittsworth not just Pittsworth but all of Disney." "let's not get ahead of our self's porky Pterodactyls will tear these creatures apart." "they work for no one nor do they cherish Plunder my friend a threats more than unlikely".

Dwarfs all shared similar characteristics their desire for wealth made them who they are letting nothing stand in their way, "we need to get busy if we have any chance of finding your friends again". "Wait..... Ryan's elf's have you seen them?" "I haven't seen an elf for over half a Century", he's facial expression surprised old wounds coxswain confusion trusting elf's he'd refrain.

18

"I told you we should of went the other way." "that would of only of put all of our lives at jeopardy", Breanna and Ryan had been at each other since they'd Realised my accident occurred. "I should turn around what if he needs our help." "he knows our destination we won't be easily missed", congregation excel intensive interchange between head scout monsoon god's oath sung Hallelujah Ryan's Oasis rejoiced.

"We need gold before passing through wombat's Cove." "say's who?" "wombat's gate keepers." "I don't have the time or Patients where are we going to find lose gold?" "Julius city". "we could just dispose of them instead." "you've gone mad…. wombats dragons their curse." "cursed how?" "once slayed electric portals will separate disney forever".

20

Rosella voltage spindle jousting tropical summer's flattened Ryan's troops, "our timing couldn't of been any worse can you see clay fields?" "it's to foggy." "over there look", one day divided Fortune's waiting to be had dependence with in arms reach. "We don't have much time come on", trying to avoid showers of rosellas hurdling hurricanes they'd barely made it out in the nick of time.

21

"You shall pass", all together as one they marched their hart's full of fear not one coward, "careful Seth's rebellion" "Breanna wait!". Setting them on fire with just one breath she undoubtedly upset the colony leaving Ryan's elf's without an alternative, "archers !" "forward!" "no…! we can pick them off from up here". Itching to get their blades dirty wisely deciding to fight with mouse instead of brawn, "Breanna one o'clock!", reinforcements glided above, "incoming!".

Riding Pterodactyls they'd bombarded Penetrating Ryan's Alliance numbers were on their side, "is there any more in the mist?" "I can't see any thing." "wait for my return". Ryan's allies despised losing even if it meant taking there own life going to the ends of the earth in order to succeed gargoyle by nature. Vabe's absence distress search parties passage leading to disaster, "he's over here!". Missing one wing he's rival headless close encounters chisel life changing resemblance he'd been lucky to still be alive.

"There's hundreds more. " "which way are they heading?" "south." "why... all they'll find's Daintree's dwarfs drepar won't be happy." " if these men fight for Seth it will give them even more reason to join our cause". No one could explain why they marched the way they did leaving all types of questions open for discussion were they Planning on terminating dwarf life as they knew it or in search of some place to call home?. "Gladiators Avoid getting seen!", scaling stone walls applauding stealth spiral's of cliff's on their belly's they'd crawl concealing their position with out alarm. "Grab the chains climb on!" "he's to stubborn."

24

"Throw him your whip now teach him who's boss", fallen leotards asphyxiated passionate chains triggered illustrate domination Allowing granted cooperation industrial individuality trademark. "There you go soldier don't give it to much slack", uncivilised classical ghetto's disturbed leaving Mackelly and I on our toes reprehensible sovereign. "Rhawk !" "what the hell is that?" "it looks like a bit of everything." "ahhaa! Cut off it's tentacle", everyone's hunger excel Tremendously in needs of satisfaction doing the best they could to help.

Procrastination monopolized disembowelling obese flesh charming Milky ways Panther colossal family anthemed, "I Couldn't be more proud our new found friend here he's got the reflexes of a cat." "careful guts you'll chock if you keep swallowing like that". Broth sons engraved resurrecting desired bolt's Craftsmanship climax describing Providence devastated thousand's renegade. "Your friends Bryan did they at least tell you where they went?" "shallow caves." "are you trying to get us killed!?",Mackelly's history troubled once an acquaintance of Seth repatriation made him feel uncomfortable conversations he'd prefer no to have.

Chalice bourbon putrefied bringing Mackelly out of his shell, "shallow caves..... I spent half my life in that place." "what happened do you miss it?" "not one bit it's nothing but trouble". "Did you make any friends?" "Seth I was one of his servants." "no........... my friends are planning war against him as we speak." "Bryan..... you know there as good as dead right." "their not alone countless numbers have just agreed to follow". The night still young hours had passed under clean banana leaves silence fantailed Convulsive disorders prayed upon Muslim righteousness Diligent amendment. "Have you seen the size of Seth's empire."

"I know nothing about him." "trust me your better off that way he'll turn you into everything your not...... look". Ingenious architecture carved from stone describe yesterday's war stories pitching hostile situations Seth's Presence Superior. "Wake up we've no time to wast", willy wag tails chirped mocking liberty rain forest's stir coming to life in slow motion while love drunk dizzy Midgets Indulge freedom. Unoccupied space craft nest one hundred yards from our current position making Mackelly more excited than ever. "It's going to get real crazy right now Bryan can you fly?" "fly...... I've still got my training wheels."

"look at me I can't fly you can..... trust me or not Bryan?" "I guess". Stepping inside I couldn't believe my eye's rocket science way ahead of it's time at least I thought so making 21st century Aeroplane's look like dinosaurs. "We got company activate auto fight mode", it's competition impeccable making it's self far from approachable following me as we raced each other to it's doom. "Way to close Bryan you need to get out of these built up areas." "The last thing I need right now is distractions." "no way.....! beginner's luck". Stressful pursuits had finally come to an end being the least of my troubles l couldn't help but wonder if I'd manage to see my new

29

friends ever again. "How are you going to make it all the way around with out getting spotted your massive." "wait here until they've pasted don't worry we'll wait on the other side". Breanna never liked sneaking around favourably she'd set them on fire Choosing to respect Ryan's wishes going back the way she came. "I'm glad we didn't wast any of our men back there Breanna you should visit daintree's dwarfs ask king Drepar if they'll join our cause". Endless nights with out sleep she flew making her way to Daintree she couldn't help but think of Bryan along the way. "Ryan's at war with Seth asking for your hand shall you expect or will you run away?" "I bow to no man why does Ryan seek my help." " he knows what's good for him he finds strength in numbers". Drepar finally agreed on the term that his people claim shallow caves as their own. "Pick up your axe!" "Snot mine gollywog." "Dozens disagree we refuse to fight Seth it's a death sentence." "do not question me!". Ryan had waited Patiently for their arrival shallow caves battle was about to flair. "Dam Bryan are they your people They look like their about to say what's up?" "yes prepare for landing". Waking up on my bedroom floor illusions hail stormy boy born heathen dripping poisonous intentions Since when Abracadabra .